FEARLESS
DRAWING

First published in the United States of America in 2014 by
Quarry Books, a member of
Quayside Publishing Group
100 Cummings Center
Suite 406-L
Beverly, Massachusetts 01915-6101
Telephone: (978) 282-9590
Fax: (978) 283-2742
www.quarrybooks.com
Visit www.Craftside.Typepad.com for a behind-the-scenes peek at our
crafty world!

10 9 8 7 6 5 4 3 2 1

ISBN: 978-1-59253-916-1

Digital edition published in 2014
eISBN: 978-1-62788-038-1

Library of Congress Cataloging-in-Publication Data
Lemon, Kerry.
 Fearless drawing : 22 illustrated adventures for overcoming artistic
adversity / Kerry Lemon.
 pages cm
1. Drawing--Technique. 2. Drawing--Psychological aspects. I. Title.
NC730.L45 2014
741.2--dc23
 2013048659

Design: www.Studioink.co.uk

Printed in China

FEARLESS
DRAWING

Illustrated Adventures for Overcoming Artistic Adversity

—— KERRY LEMON ——

Quarry Books
100 Cummings Center, Suite 406L
Beverly, MA 01915

quarrybooks.com • craftside.typepad.com

CONTENTS

I love drawing.

This is lucky because I spend every day drawing.

I'm an artist and my drawings are commissioned internationally for lots of clients including the *Los Angeles Times*, Sony Japan, Heineken, Swarovski, *Harper's Bazaar*, De Beers, *Elle* Spain, Harrods, and Le Bon Marché.

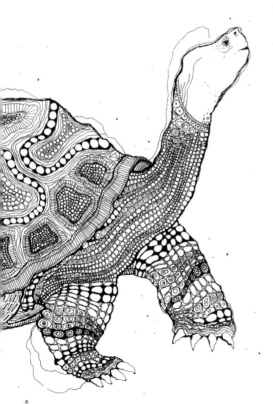

I am completely addicted to the power and pleasure that drawing affords me. Each day I get to start out with a blank sheet of paper and create ANYTHING I can imagine. I feel the same way about drawing today as I did when I was a child. The physical pleasure of sweeping marks, scrubbing felt-tipped pens, and smearing paint. Exploring, defining and creating the real and imagined world and capturing it all just how I see fit.

There is nothing I would rather do.

When I tell people what I do for a living a frequent response is a version of "I wish I could draw!", but there is so much baggage and fear attached to it. I regularly teach workshops particularly focusing on people who feel nervous drawing. The idea of being able to draw is so attractive, and yet unless we already feel confident in our abilities it is seen as an unreachable goal. This is such a shame. If we aspired to play the guitar then the fact that we were not already accomplished wouldn't prevent us, we would just begin, practice, and from wobbly beginnings would improve. For some reason drawing is not viewed in

this light, but rather as something which only a few lucky people are naturally talented at. This is rubbish.

We all started out naturally and unselfconsciously drawing in childhood; enjoying the physical PROCESS of applying paint or crayon to paper, unconcerned with the finished artwork, the PRODUCT of our creativity. The problem is that early on we are made to focus on the product, the result of our labor. We are encouraged to accurately capture the world around us, and gradually our ability to draw is defined by how close to reality the finished product is. Most of us quickly become disheartened. We spend miserable hours in class attempting to draw a bowl of fruit accurately, grinding endless erasers to dust in a miserable attempt to get it "right." The pleasure of the process becomes merely an academic battle to turn a three-dimensional world into two dimensions on your page. You are judged by yourself, peers, and teachers, and it is quickly determined who in the class can and can't draw. It is this environment that makes people stop drawing. It was that environment that nearly made me stop drawing!

Today my drawings are fairly representative but include lots of wibbly wobbly lines, dodgy perspective, and made up bits. I change the world however I choose, adding petals to a flower or removing entire floors of buildings. I take pleasure in creating MY version of the world through drawing. Much of my work is fibs and fiddles. Absorbed in the process I add zigzag tiles, stripes, and spots which in reality do not exist. I am not a camera, the work is not a carbon copy of the world, but each drawing speaks of the world whilst also speaking very loudly of me. There is no one way to draw and I am wholly uninterested in trying to make you draw like me. I want you to have the confidence and freedom of expression to draw like you. Drawing is like hand-writing. Only by embracing the marks that our own hands can make and exploring our own drawn response to the real (and imagined) world will you find your own way forward.

I have written this book to make you fall in love with the process of drawing again, to rediscover the physical pleasure and joy of putting pencil to page. Drawing can become your private refuge, a place to hide away, explore, create and do something just for you. By actively seeking enjoyment in drawing (focusing on the process), we will begin to draw regularly, and by drawing regularly our work (the product) will inevitably improve! I want you to be inspired, to experiment, and to discover or recover your own drawing voice. It is designed to create a new relationship with your drawing, a chance to reconnect and appreciate your unique drawn line.

Drawing brings me so much happiness every day and has completely influenced the way I view the world and observe my surroundings. It offers a freedom and power to create, escape, relax, indulge, and explore, and I am so excited to share my passion and enthusiasm with you.

Hello Pencil

This book is all about discovering your own unique drawing style—the dashes, scribbles, strokes, and dots that you favor. To do this, I want to equip you with a toolbox full of possible marks which you can select from and apply at will. In time, your favored marks and approaches will autograph your drawings as uniquely yours.

This book has been designed for you to draw directly into it, allowing you to keep all your drawings in one place, and in time to serve as a record through the chapters and the progress you have made. For this first adventure the only thing you'll need is a pencil.

Pencils vary in hardness from around 9B (very soft leaving a thick, black stroke) up to 9H (very hard leaving a thin, pale gray stroke), and everything in between. At school you might have had an HB, the standard pencil for writing, which is right in the middle. But for drawing I recommend you start out with a 2B as it's flexible and can be manipulated to create a wide range of effects. Remember to always buy the very best art materials you can afford. Don't be distracted by the giant tins of cheap pencils—invest in one really good 2B and a metal sharpener.

Please don't just read through this chapter as you won't create a personal language of drawing through theoretical study. Instead,
be brave,
take part,
try,
begin.

So here we are then, time to start.
Take a deep breath and grab yourself a pencil...

GRIP

To begin, we're going to explore your pencil grip, requiring nothing more challenging than writing your own name. Have a look at how you are naturally holding your pencil and write your name below.

Name

Next, hold the pencil really high up, right at the top end and write your name again. Note how this time you haven't had as much control or applied as much pressure, so you've now got a paler "wobbly" version of your name.

Name (holding pencil high up)

Now try writing your name with your "wrong" hand, which is likely to look rather alien compared to your usual handwriting—askew, uncontrolled, and unfamiliar.

Name ("wrong" hand)

Next let's look at the angle we apply the pencil to the page.

With a newly sharpened point, hold the pencil straight and vertical and write your name.

Name (pencil tip)

Again, laying the pencil horizontally, apply the side of the point to create a broad line and write your name again.

Name (side of point)

These are all techniques I regularly employ in my drawings. When my drawings start to look a little hard and tight, I can find a more relaxed whimsical line by swapping hands, adjusting the angle, or changing how high up I hold my pencil. We will go on to explore lots of different marks, but remember the freedom and variation you can find just in your pencil grip.

PRESSURE AND SPEED

How hard you press your pencil against the paper will have a dramatic effect on the quality and atmosphere of line you create. Awareness of pressure will allow you to manipulate your drawn lines however you choose to articulate the object you are drawing, or to evoke a particular mood in your work.

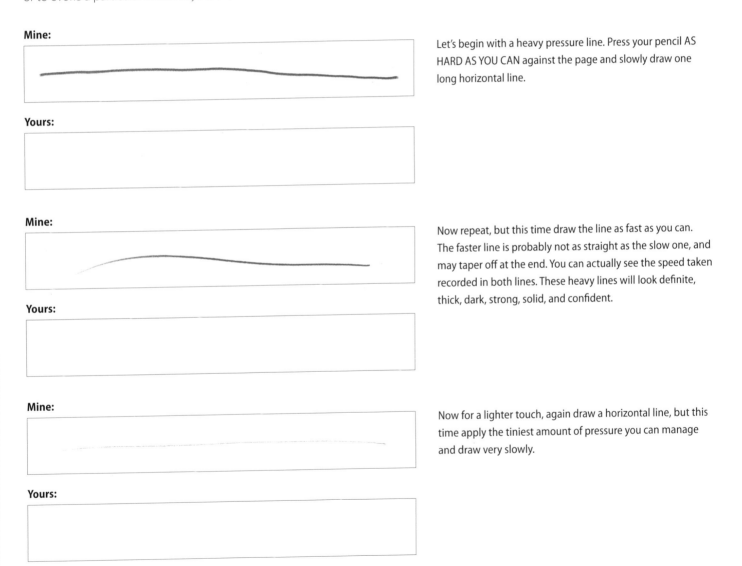

Mine:

Yours:

Let's begin with a heavy pressure line. Press your pencil AS HARD AS YOU CAN against the page and slowly draw one long horizontal line.

Mine:

Yours:

Now repeat, but this time draw the line as fast as you can. The faster line is probably not as straight as the slow one, and may taper off at the end. You can actually see the speed taken recorded in both lines. These heavy lines will look definite, thick, dark, strong, solid, and confident.

Mine:

Yours:

Now for a lighter touch, again draw a horizontal line, but this time apply the tiniest amount of pressure you can manage and draw very slowly.

Mine:

Now draw the line again, applying the same faint pressure, but this time very fast.

Yours:

It's so hard to maintain a consistent pressure, and therefore width and style of line when drawing quickly, but again this can be manipulated for use when we choose. These lighter lines will look thin, light, quiet, soft, and unsure.

Mine:

I really like to manipulate a varied pressure line with my pencil, having lines that move from hard and thick to soft and light by adjusting the pressure applied.

Yours:

Mine:

I also like to make my line look more uncertain. By shaking my hand slightly while I hold the pencil just above the page, I allow the pencil to lose and find the surface of the page as I draw, creating an interrupted "lost and found" line like this.

Yours:

My personal preference is always for a nervous, stuttering line and a delicate touch. As my confidence with drawing has increased, I have to work hard to keep this line in my work.

SHADING

Shading is used to describe light and shadow. Look up now and try to determine where the light and dark areas of your view are. This might be hard to see since we are distracted by colors and textures, so screw up your eyes and squint. This will cancel out much of the additional information allowing you to see more clearly where the lightest and darkest areas are. For example if a lamp is shone against the left-hand side of a football, then the lightest side will be the left and the side in shadow, the right side, will be the darkest.

I often use shading, stylistically adding dots at whim to provide areas of dark interest, drawing the eye to particular areas. I never enjoyed the endless academic lessons where we were supposed to accurately and consistently depict light and shadow, and so I have settled on a mixture of real and imagined. My shading is informed by reality but supplemented by my imagination; I add light and shadow wherever I choose. I'm not a camera and so I can create my own version of a world which can be as close or as opposed to reality as I choose. You, in turn, can shade as close or as opposed to reality as you desire, combining both real and imagined light and dark to create the effect you seek.

Mine:

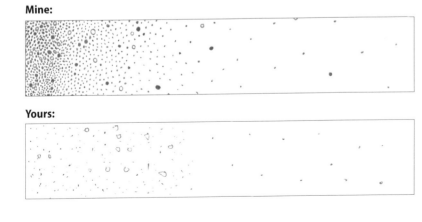

Yours:

There are lots of different ways to shade. My preference is the use of lots of tiny dots packed closely together for the darker areas and further apart for the light areas, so let's start with dots.

You can see variation in the size of the dots, adding both colored and empty circles for added interest. Use the space below each of these shading examples to try for yourself and work out which method you prefer.

Mine:

Hatching is another way to shade, creating parallel lines close together for darker areas, and further apart for the light sections.

Yours:

Cross-hatching allows you to create more depth. You can cross diagonally, vertically, and horizontally, adding more and more lines at different angles to create the darkest tones. Here I adjusted the pressure used to create paler lines and darker lines as required.

Mine:

Yours:

Colored shading allows for smooth graduated tones, pressing lightly for the palest gray and hard for black. It takes practice to smoothly move between dark and light areas without creating harsh lines, but it's a fun exercise to do on the phone, commuting, or in front of the TV and you will quickly improve.

Mine:

Yours:

ADVENTURE

2

Hello Eraser

I used to think of the eraser as a miserable partner to the lovely pencil, synonymous with mistakes and corrections, of being stuck and getting grumpy. But no more. I've always favored the line, but in teaching I've watched many, many people respond to and enjoy a more sculptural approach, playing with depth, pushing the page backward and pulling it forward by adding darkness with the pencil and light with the eraser. It's an exciting technique and a great way in for those who struggle to make a start when faced with a blank page.

This chapter will make you see your eraser not as a tool for correction, but as another drawing medium. It's an opportunity to use your eraser in collaboration with your pencil to create a wide range of marks on your page. As you work through the book, you will start to favor some techniques over others; this is a natural process in helping you to find your own drawing style. Remember, you don't have to like all the techniques, but it's really important to try them all so that you can find your own personal approach to drawing.

Again, I encourage you to do the exercises, as it's only by trying out all the different techniques that you'll find your own personal approach. When you started this book your drawing toolbox (the techniques you had stored away ready to use) may have been nearly empty, or perhaps full but a bit rusty! By following each chapter and engaging in the exercises for the different techniques, you will emerge with a vast number of options when tackling your future drawings.

MATERIALS

There are a wealth of different erasers to buy, all shapes, sizes, and textures. Many people prefer kneadable erasers, rectangles of very pliable rubber (much like Plasticine or Blu-Tack) that tend to be boxed and can be molded to a point, sharp tip, or complex shape for precise erasing in tight spots. I always choose a soft one (rather than the really hard plastic ones), but it's good to try a few to see which you like best. For now, use whatever eraser you have on hand; it will serve its purpose, and then in time you can replace old materials with those you prefer for future use.

APPLE

I'm going to show you my step-by-step approach to drawing with an eraser. Here I chose an apple, as they have a really simple silhouette, which makes for a nice, easy start for us. A 4B or 6B would be good for this, but if you don't have these, you can make do with your 2B. Go slowly and take your time to build up the color or some hard pencil marks will likely show.

1. Color in your page, keeping an even pressure and avoiding any harsh pencil strokes.

2. Continue coloring until the page is completely covered.

3. Use your eraser to block out the silhouette; here it's nice and easy since our apple is a circle.

4. Use your pencil to darken around the white edge. Try shading from the dark edge back into the mid gray.

5. Pick out the apple stem with your eraser and add some shading to your apple. Remember to leave a thin white space where two dark areas meet to prevent your apple from bleeding into the background.

6. Use your eraser to add more white and your pencil to add more gray until you get the effect you're after. Here I added more definition and detail with the speckled skin.

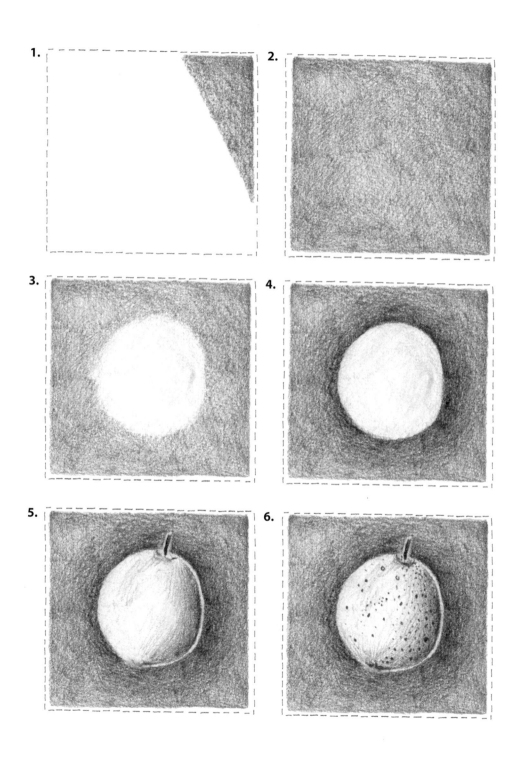

1.

2.

3.

4.

5.

6.

PRACTICE

Okay, your turn. Use these pages to practice shading. (Or, if you'd rather, you can always complete this task on separate sheets of paper and then glue them into your book.) If apples aren't your thing, try your favorite mug, your toothbrush, or a shoe. Lay down a smooth, gray ground ready for rubbing out. Use a consistent pressure and color in slowly and carefully. Begin by just erasing the rough shape, and then play with adding and subtracting detail and tone until you get the effect you like.

TIPS

◆ Once finished, give it a spray of cheap hairspray to fix your drawing into place and prevent it from smudging.

◆ At this point, try not to worry about how your finished drawings are looking; remember you are just beginning! Be kind to yourself and push ahead with the knowledge that if you keep practicing you WILL get better.

◆ This chapter explored a tonal approach to drawing, whereas the first was more concerned with line. You might already have noticed a preference for one of the two techniques. I'm always more drawn to line, but enjoy introducing a tonal approach into some of my drawings to add interest and contrast.

ADVENTURE

3

Drawing as Pattern

I LOVE pattern and find it deeply inspiring. I add it to all my drawings, even inventing it where it fails to exist. I find constructing areas of pattern in my drawings deeply meditative; it is a relaxing, repetitive, simple task that allows me to become completely absorbed in my drawing (and completely unaware of the time!). For me, pattern is play. It is the closest thing to doodling I have found, and it allows me to take an imaginative, creative, and deeply personal approach to my work.

We are surrounded by a vast number of inspiring patterns every day; think of a brick wall, braided hair, parquet flooring, and all the wonderful patterned textiles in your home and wardrobe. Have a look around the space you are in now—there will be a dazzling array of patterns if you look for

them. Because I draw every day, this has had an enormous effect on the way I see. I really look at my surroundings; I'm drawn to pattern so I notice the tiles on a roof, leaves on a fern, or stripes on a shirt. When you begin to draw regularly you will become aware of a shift in how you look at things. Perhaps you'll feel drawn to observing texture or light and shade, but you will certainly change the way you see your world.

This chapter is completely about play. I'll give you a few ideas to copy and get started with, but fill these pages with many more of your own ideas. Use this book as a safe private place to document all your experiments, which you can refer to as your journey continues. Just get started and doodle!

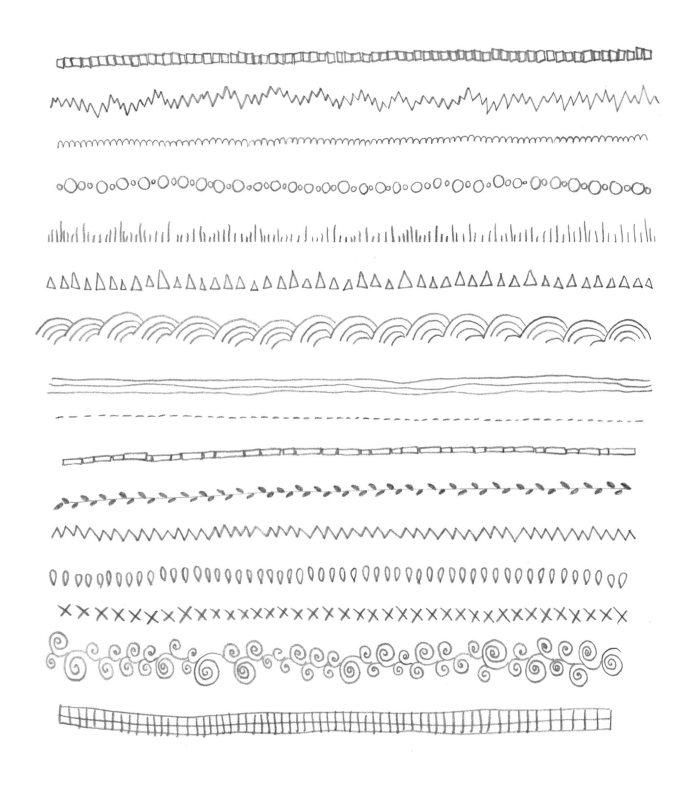

PATTERN PRACTICE

Use this page to practice different patterns. If you can find some colored pencils, that would be really fun! Remember to keep your sharpener close at hand for a nice, sharp point.

Practice doodling these patterns while you're in meetings, on the telephone, or in front of the TV. Gradually, pleasing repetitive shapes and patterns will emerge.

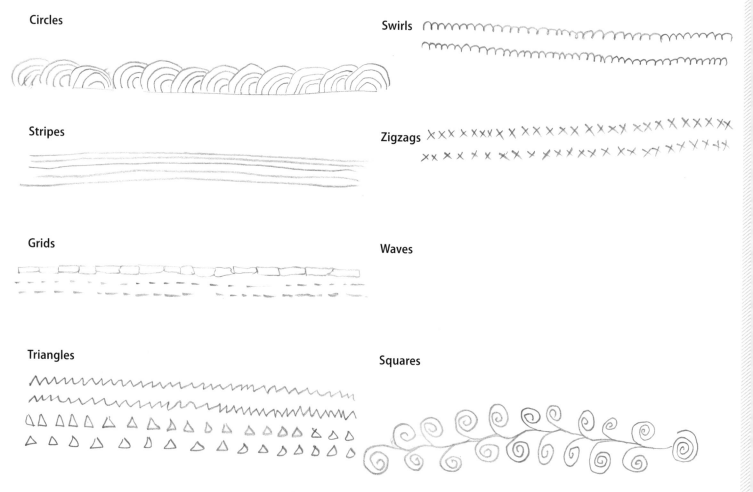

Circles

Swirls

Stripes

Zigzags

Grids

Waves

Triangles

Squares

RHINOS

I drew the outline of this rhino while watching the animal at a zoo in the south of England. It was a freezing cold day and once I'd completed the basic outline I retreated to a cafe to fill the interior with glorious, imagined patterns. I worked slowly with no preconceived plan, just building it up gradually while drinking a much-needed hot chocolate!

As you continue with the exercises in this book, watch for and record interesting patterns that you see around you—sketch the lines in the surface of a wood table, the weave of a sweater, or the arrangement of the seeds in a pinecone. If this book is too big to carry with you, try a small sketchbook—even scraps of paper or a receipt will do. The important thing is to make a little time each day to really look at the world around you and enjoy creating small drawings, doodles, or scribbles. Consider collecting your pattern doodles in a single sketchbook that you can refer to later on for inspiration.

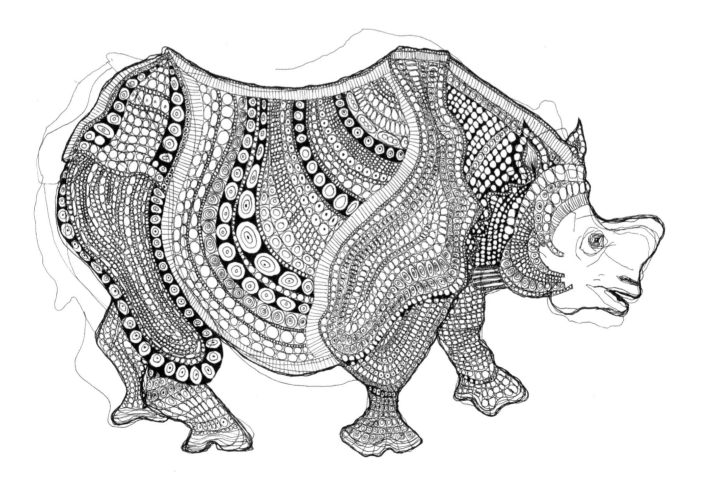

Now it's your turn! Begin with the rhino outline and fill it in with patterns and shapes

TIPS

◆ Begin by defining some anatomical outlines within the basic shape of the animal.

◆ Splitting up the large interior into smaller sections will make the patterning easier to tackle.

◆ Repeat different patterns as you move around the space to create areas that relate to each other. For example, I repeated a row of circular patterns to define the rhino's ribs.

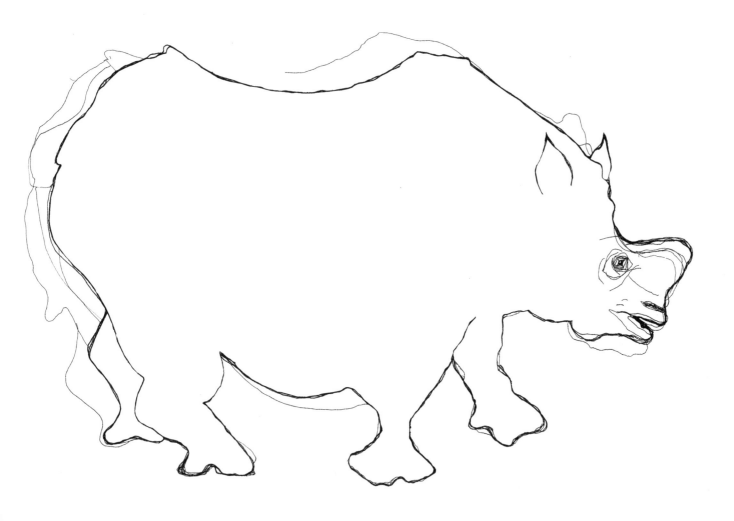

ADVENTURE

4

Drawing as Frottage

Frottage is essentially a posh way of saying "rubbing"—it's taking a textured surface, placing a sheet of paper on the top, and using a soft pencil, crayon, charcoal, or pastel to color over the paper and reproduce the texture below. It is a great introduction to printmaking as it's quick, clean(ish!), and requires only basic materials.

There's a long history of using this technique (check out the master Max Ernst), and in our pursuit of a full toolbox of ways to create drawings, this is a fun and inventive tool. Frottage offers a chance to gain a real sense of place that particularly appeals to those, like me, who are attracted to texture and pattern. When traveling, I always like to include frottage in my sketchbooks as it enables me to take home a real piece of the place visited: the textured concrete pavements in Barcelona, Spain, the trees in New Hampshire, United States, and the railings on bridges in Paris, France. These rubbings bring me straight back to the place, far more powerfully than a photograph or purchased souvenir.

Frottage is more than a little addictive; you quickly begin to assess your surroundings based on texture alone, seeing with your sense of touch and analyzing each object for the print it can offer. It's a good idea to have a file folder in which to store all your rubbings as you never know when your drawing may cry out for just that texture you captured in an earlier frottage. An even better idea is to be diligent about taking notes. On the back of each frottage, write down where the rubbing was made and the subject so you will be able to re-create it when needed.

MATERIALS

Wax crayon

Wax crayons are perfect for creating rubbings. Usually made from dyed paraffin wax, crayons provide a clean, stable print of your surface. I find the drawing point on crayons to be a little small for large areas of frottage, so I tend to peel off the paper wrapper and use the side of the crayon instead.

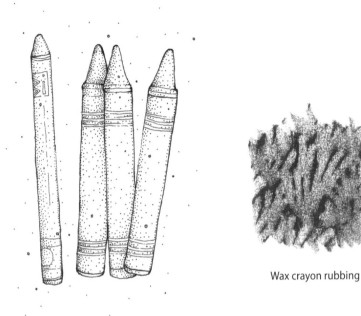

Wax crayon rubbing

Soft graphite pencil

Soft graphite pencils (6B–9B will give you the best results) offer a really good, clear print. Again, I find the drawing point on pencils to be a little small for rubbing, so I tend to favor the short, chubby woodless pencils or bars. Visit an art supply shop (or look online) to see the range available. Colored pencils are too hard for large rubbings, but perfect for small items like coins.

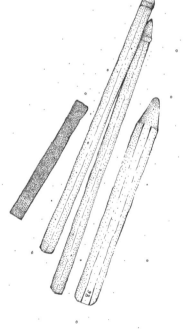

Graphite pencil rubbing

Charcoal

Charcoal is created from slow burning wood, which creates a drawing medium of carbon and ash. It is soft, brittle, and VERY smudgy—whenever I use charcoal I get completely covered in the stuff. I favor vine charcoal, which is usually made from willow or linden. I like the skinny wobbly black sticks of varying thicknesses, and just embrace the mess that comes with it. You can also get compressed charcoal, which includes a binder to make it less crumbly, or a charcoal pencil where the compressed charcoal is encased in wood—take your pick!

Charcoal rubbing

Soft (chalk) pastel

Soft pastels—sticks of pure powdered pigment with a binder—are basically the artist's version of pavement chalk and come in a beautiful, dizzying array of shades.

Soft pastel rubbing

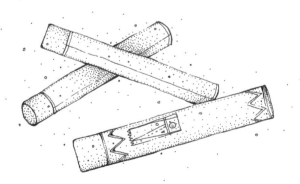

Oil pastel

Oil pastels come in stick form and use the same pigments as soft pastels, but with an oil binder to create a rich, buttery crayon. Pastels are softer in texture and richer in color than wax crayons.

Oil pastel rubbing

FROTTAGE AROUND THE HOUSE

Take the opportunity now to explore your home. Grab a stack of printer paper and a selection of different drawing tools and take rubbings wherever your eyes land. Textured wallpaper, kitchen surfaces, wood, tiles, ceilings, radiators, draining boards, furniture, and carvings all create fantastic textures. Open the cupboards and empty your pockets—try colanders, forks, keys, and coins.

Now select your favorite pieces, cut them out, and stick them here. Make a note of what drawing tools you used (crayon, pastel, pencil, etc.) and what you used to create each texture (coins, tile floor, cloth-bound books, etc.).

TIPS

◆ Don't forget to spray your pencil, charcoal, and pastel rubbings with cheap hairspray to stop them smudging and fix them into place.

◆ Many different media are wonderful for creating rubbings. The ones chosen here are all black, but remember you can choose any color you like!

◆ Buy only one of each pencil, crayon, charcoal, or pastel to try out before you commit to buying a full box.

FROTTAGE OUTSIDE

Now venture outside with a stack of cheap printer paper and your drawing tools. Explore a wide range of trees, looking at the variety of textures from different species. Turn a leaf upside down to expose the veins and create a beautiful, delicate rubbing. Look beyond nature. Drain covers, concrete floors, brick and stone walls, keyholes, and mailboxes are all waiting to be printed.

Return home and spread out your rubbings. Which are your favorites? What were your successes? Cut them out and add them here. Again make a note of the medium and textured surface used so you can easily re-create them.

Continue to create rubbings, making notes of new textures and places you'd like to capture using frottage. Keep a few sheets of paper and a wax crayon in your bag—you never know when the perfect texture will appear, ready for rubbing!

TIPS

◆ Bring a shoulder bag or clipboard to store your drawings as you collect rubbings —you will quickly run out of hands!

◆ Find time to search for Max Ernst online and explore his mastery of the technique.

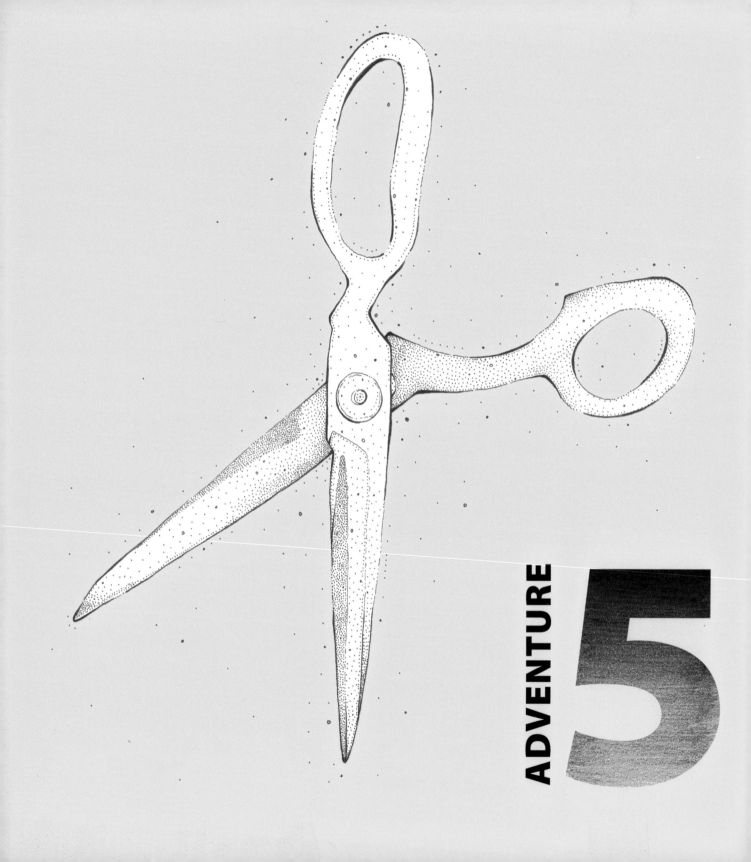

ADVENTURE 5

Drawing with Scissors

We are exploring drawing in its widest sense, which means using anything that makes a mark—even scissors. It's important to try a vast array of possible techniques to find the one method, or the combination of methods, that really suits you.

The master of drawing with scissors was without question Matisse. In the last four years of his life he was confined to his bed, and created his iconic drawings using sheets of painted paper from which he cut wonderful freehand images. This skill, like every other, requires practice. It will take time for your eyes and hands to learn to work together, but the only way to become good at something is to start doing it and keep doing it. We need to really focus on enjoying the process, the sound and sensation of your scissors slicing and snipping through the paper. Don't worry too much about the final product. Be kind and have patience with yourself, allowing yourself to have a go of it, knowing that disappointments and great successes will all be part of your journey.

Drawing with scissors is a great exercise and it makes you really look at the outline of objects. Find yourself a pair of scissors, including a big pair for speed and then a smaller pair (nail scissors or similar) for the detailed bits. Use colored paper if you have it, but if not then just prepare some sheets of paper by shading them with graphite or colored pencils.

SHAPE PRACTICE

Okay, let's get started. Remember to cut out your shapes freehand, which means without drawing them first. Take a deep breath and start cutting. It's no problem if it's wobbly and wonky—that's the beauty of making something by hand rather than with a machine! Copy my work here and paste yours alongside. Draw inspiration from the master, Matisse, trying circles, squares, triangles, zigzags, and waves.

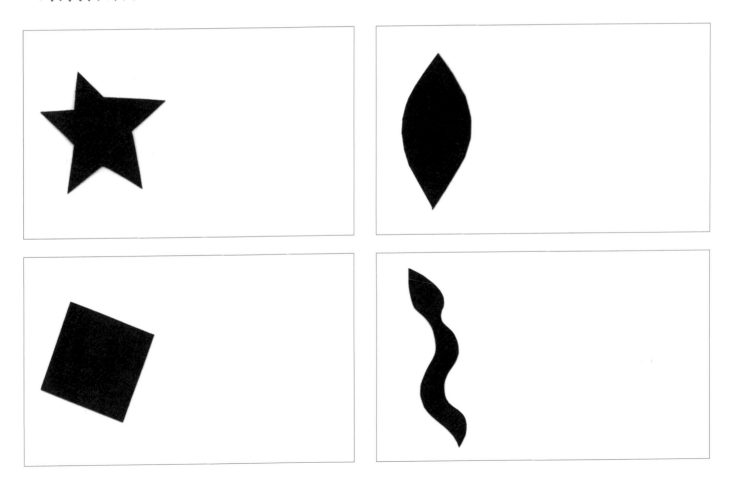

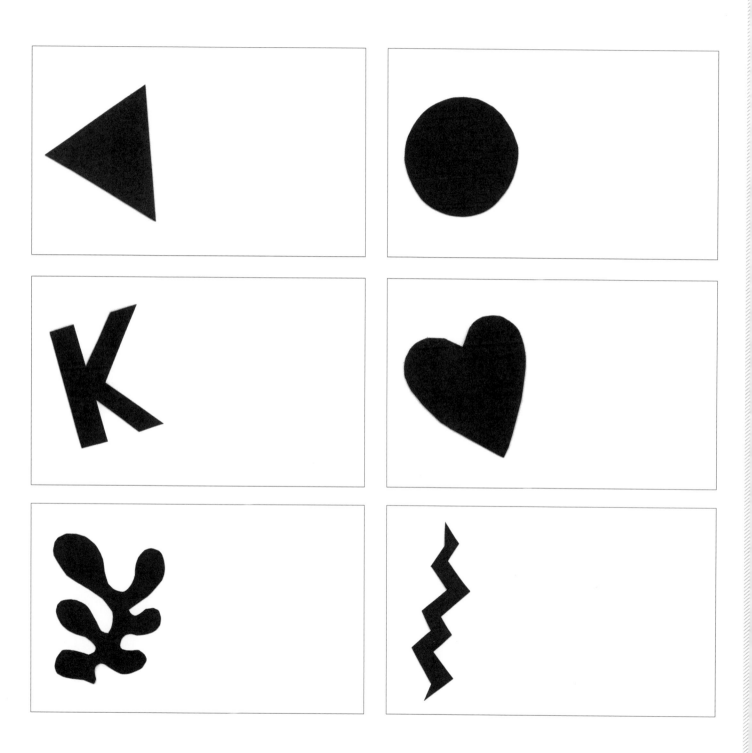

LEAVES

Here I have cut out a branch and started to cover it with leaves. I want you to cut out some leaves and paste them to my branch. They can either be the same shape as mine or completely different. How does it look?

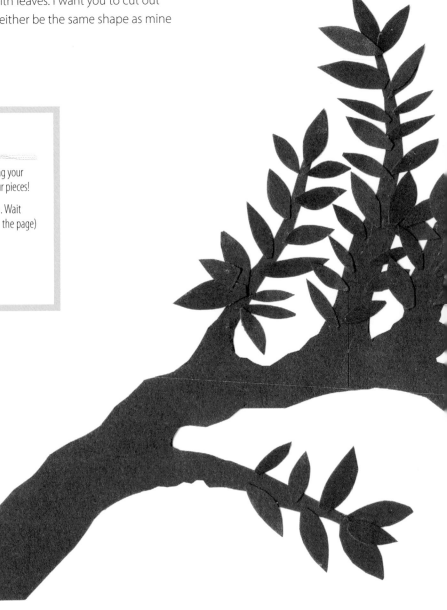

TIPS

+ Store your cut-out shapes in a cup before pasting them in. Before long your desk will be covered in snippings and you'll begin to lose track of your pieces!

+ Spend time moving the shapes around before pasting them down. Wait until you are happy with the composition (the layout of shapes on the page) before gluing down the pieces.

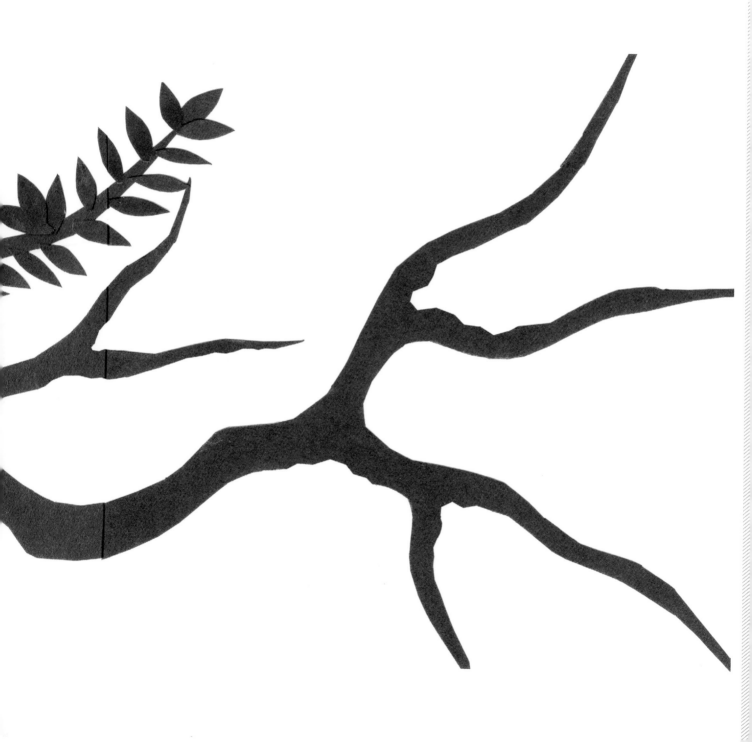

Drawing as Collage

This adventure explores nothing more complicated than cutting and sticking recycled old papers and images to create brand new pictures. We've already tried drawing with scissors, so this chapter is really about building on what we've done so far. You'll need some glue. I use white PVA (Elmer's, school, or similar) because it is washable but has a really strong bond.

Collage turns everyone into a magpie—you'll start to collect all sorts of papers, cards, and plastics, and it's a great way to recycle! For now grab an old shoebox, bag, or crate and hunt around your house for suitable flat materials. Any of the following are worth a try.

- Packaging and wrappers
- Gift paper
- Envelopes
- Handwritten notes and lists
- Greeting cards and postcards
- Magazines and newspapers
- Receipts
- Old books
- Calendar pages
- Maps
- Tickets (public transportation, theater, etc.)
- Wallpaper samples

Once you've gathered a stack of found papers, supplement them with some homemade papers: chop up old drawings, color papers using paints or pencils, or create textured pages of frottage.

BIRDS COLLAGE

For this exercise, I'd like you to collage more birds to these branches.

Continue to collect collage materials. I have a big folder in my studio organized by color, so it's easy to find just the right piece of collage. When I travel, I really enjoy collecting and saving ticket stubs, photographs, postcards, and brochures, as it's so nice to then incorporate these into my work.

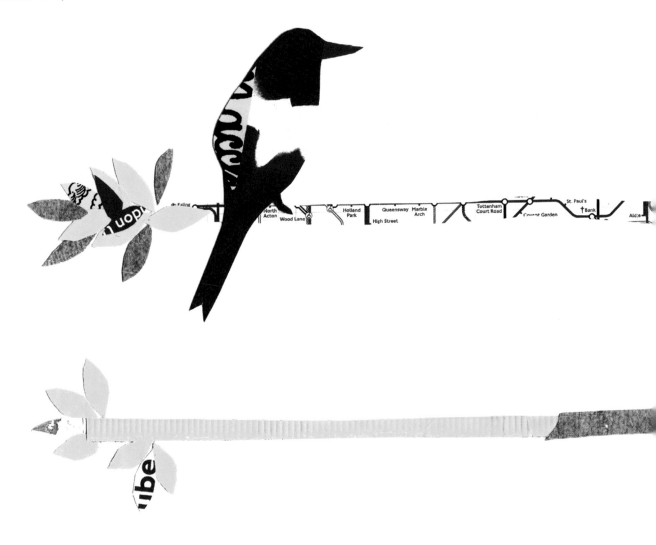

TIPS

◆ You can either cut and embellish your own shapes freehand or trace my silhouettes and use them as templates for cutting out your own birds.

◆ Feel free to hand draw elements that might be too small to cut, including eyes, beaks, or tail feathers.

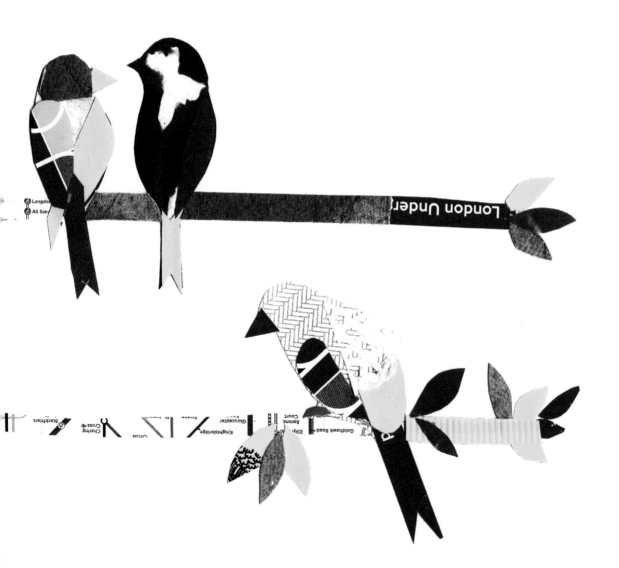

Hello Brush

Drawing with a brush is so expressive, and it opens an entirely new toolbox of possible marks. I have completed this adventure using a bottle of India ink, a rich and fluid medium that can be purchased quite cheaply in a single bottle. India ink does stain, so take particular care to roll up your sleeves and protect your work surface.

If you don't have any India ink, then you could substitute:

• Watercolors
• Bottled writing ink
• Kids' poster paints
• Cup of cold, strong, black tea or coffee

You will also need a paintbrush. I used a size 4 round watercolor brush for all the marks you see in this chapter. Please ignore the cheap sets and just buy one good brush (4 or similar size), taking care to wash it carefully, reshape it with your fingers, and allow it to air dry after each use.

We have already covered many of the techniques referenced in this chapter using a pencil, but it's fascinating to see how different these effects can look when created with a brush. Many artists prefer the lyrical nature of drawing with a brush, and it is definitely a very different physical experience from the drag of graphite across the page.

PRACTICE BRUSH MARKS

The marks you make with your brush are more variable than those you can make with a pencil.

Mine:

Yours:

Let's start out with a simple exercise of drawing lines, making them straight, wavy, fast, and slow. Draw as many different lines as you like, taking time to really explore the feel of the brush on the page.

Mine:

Yours:

To draw a thin line, hold your brush vertically and apply very little pressure, then increase pressure by pressing down to create a thicker line. Adjust the pressure over the course of the stroke to create a line of variable thickness.

Mine:

Yours:

Create a curved mark by guiding the brush with a small, semicircular movement of your wrist.

Mine:

Create a flamelike flick by touching the point of the brush to the paper and flipping your wrist upwards.

Yours:

Mine:

Make a small dot by holding your brush vertically and allowing just the very tip of the bristles to touch the surface of the paper. To create larger dabs, apply more pressure and alter the angle of your brush.

Yours:

Mine:

When you've applied most of the paint to the page and the brush is nearly dry, you will see how the brush applies the paint in a scratchier texture; this is called a dry brush mark.

Yours:

PAINTED INITIAL

In this practice exercise, I've used many of the brush strokes we've just tried to paint my first initial. Paint your initial on page 51, practicing the brush strokes we've just learned and inventing more of your own.

Continue to play with mark making using your brush. If you really enjoy this technique, collect a few more brushes for further experimentation. I have a few travel paintbrushes of various sizes that I like to use whenever I'm out of the studio. Travel brushes are great because they are designed to allow the delicate bristles to fold inside the body of the brush, protecting them while they're in my bag. I also have a paintbrush where the body of the brush is plastic and can be filled with water or ink (I usually fill mine with coffee!). Then you're able to paint simply by gently squeezing the body of the brush to release the liquid. I find these fantastic when I'm out and about as they allow me to paint easily without too much additional equipment.

8

Continuous-Line Drawing

In this chapter we are going to explore continuous-line drawing—meaning creating a drawing without lifting your hand off the page. It sounds easy but it is a real challenge! The pencil must remain pressed to the paper until the drawing is complete, creating an entire drawing with a single line. This means you need to be very thoughtful about how you move around the page, as each time you double back to an area, a new line will appear.

Creating drawings in this way is a deeply sensory experience, which focuses on capturing the outlines of objects. Enjoy the looping and the zigzagging to return to different areas of your drawing and create more detail. Remember that you can add definition by using pressure to emphasize some areas of the drawing and make others less visible. This technique can encourage a more personal and lyrical approach than creating a drawing with a series of individual staccato lines.

Sometimes when I am anxious about a looming deadline, I notice that my drawings begin to look a little tight and forced; I can actually see the stress in the lines, which become hard and tight rather than loose and lyrical. When that happens, I try this exercise. By creating a few continuous-line drawings, I can engage in the process of drawing, relax, warm up, and then return to my commission with a better line.

Okay, grab your pencil as this is all you're going to need (put the eraser in a drawer, it is officially banned for this chapter!).

CONTINUOUS-LINE DRAWING

I raided the cupboard and pulled out some cups to draw here, so go and do the same (or feel free to grab something else to draw if you prefer). Now take the challenge of drawing each item without lifting your pencil from the page. This is easier to do if you remember to work slowly. Slowly run your eyes along the edges of the cup and mimic this line with your pencil on the page. Relax and don't worry about how it looks. Just focus on the physical pleasure of pulling the pencil across the page and leaving the mark of where you have been.

Keep practicing these continuous-line drawings. They will not only help sharpen your observation skills, but they're also a great warm-up exercise.

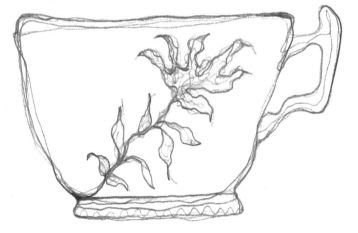
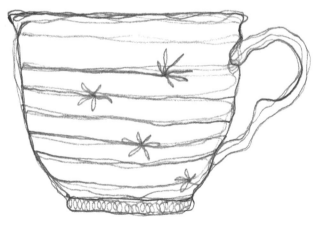

TIPS

* Before you start to draw, spend two minutes (time it—it's longer than you think) really looking at the subject. Having a clear understanding of your object will dramatically improve your drawing.

* Look at the object you are drawing more than at the page.

* Relax and take your time. You cannot take your pencil off the page, but that doesn't mean you need to be moving it constantly.

* Apply more pressure to define edges of your drawing as you move around with your pencil.

ADVENTURE **9**

Drawing with Wire

Drawing with wire is a really beautiful way to create a line drawing in space. I have lots of these drawings taped to the walls of my studio and I love their elegance and the different shadows they create over the course of the day. Using wire is a sculptural approach to drawing, allowing us to create lines in three dimensions and to view our emerging and finished work from every angle. These drawings work beautifully hung as mobiles or simply taped or pinned directly onto the wall. For inspiration before you begin, research the exquisite wire drawings of Alexander Calder and CW Roelle to see how far this approach can be taken and inspire you before you begin.

You will need a small amount of thin, soft, pliable wire that is really easy to bend with your fingers. I recommend floral wire, but you can also use 2mm aluminum wire or modeling wire. I can cut floral wire with my scissors, but you might need to use pliers depending on the thickness of your wire. When drawing with wire remember to watch out for the end as you don't want it to accidentally ping into anyone's eye!

The tricky thing about drawing this way is how each bend and fold created moves the existing bends and folds. This means you have to keep altering and adjusting as you go, keeping in mind the overall look of the drawing, while also focusing on the small section in progress. The finished pieces are gorgeous but very fragile; they're easily squashed so store them in a safe place until you're ready to tape them into your book.

CUPS

To complete this exercise, we will repeat the adventure in chapter 8—creating a continuous-line drawing without breaks—but this time in three dimensions. Let's revisit those cups. We are now familiar with their shape, so let's re-create our continuous drawing in wire. I want you to draw the entire silhouette of the cup using one long piece of wire. For now make sure you are working from the actual cups rather than your drawings. This is important as we are now at the stage in our journey where we are beginning to really see. All the answers of how to draw an object can be found through careful and thoughtful study of the object. The problem is that when we are asked to draw, we panic and we rush into drawing without any real contemplation of the object we are trying to draw. Instead, slow down, spend time looking, enjoy the process, and don't fret about the end result. In time your looking and drawing skills will develop in tandem; you will learn how to look more closely, and with practice your hand will respond with confidence. For now save your wire drawings in a safe place where they will not get damaged.

Once you have completed all the adventures in the book, tape your wire cups here.

BUTTERFLY

Here's half a butterfly; I'd like you to make the other wing on the opposite page. You can see it's been built up gradually, using many small pieces of wire. I started with the wing outlines and then created the designs within them. Don't worry if your design is not symmetrical. You can follow my design if you'd prefer, but please do take the time to explore your own shapes and patterns as well. Once you have completed all the adventures in the book you can tape your wings on the opposite page.

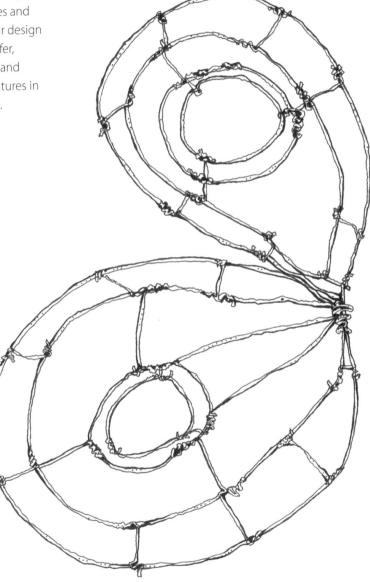

TIPS

- Create the outline with a large piece of wire and then fill the interior with pattern by attaching smaller pieces of wire to your outline frame.

- To join one piece of wire to another, wrap it around in a circular fashion to create a bind and then snip off any overhanging wire.

- Be careful using small pieces of wire; don't make them too short as it will be difficult to bind them to the structure.

ADVENTURE

10

Drawing as Print

Okay, time to get a bit messy! Cover your worktable and put on some old clothes. As in Adventure 4: Drawing as Frottage, we will be using the textures of real objects to create our drawings. We're going to explore the wide range of marks that can be obtained from printing with objects. Throughout this adventure, I used India ink (and wore rubber gloves!) to create my prints, but you could also consider printing with the following.

• Watercolors
• Writing ink
• Kids' poster paints
• A cold cup of VERY strong black coffee

Begin by collecting textural objects to use for printing. These items are going to get messy, so only use things that you don't mind recycling after making the prints. Here are a few ideas:

• Bubble wrap
• Marshmallows or candy
• Pasta
• Wine corks, bottle tops, and caps
• Leaves, twigs, flowers, acorns, pinecones, and feathers
• Drinking straws
• Cotton swabs or cotton balls
• Lace or doilies
• Old toy cars (try rolling the wheels into the ink and then along the page)
• String
• Cards

PRINTING IDEAS

Here you can see the range of marks I created after a quick rummage in cupboards, the recycling box, and a walk outside.

Bubble wrap

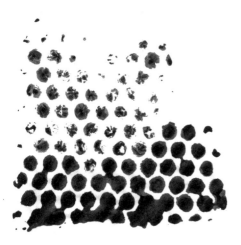

Bottle caps

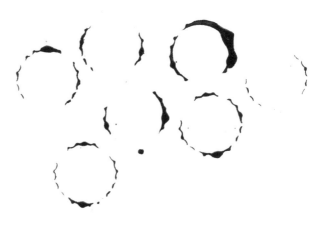

Cork

Leaf

Drinking straw

Card

String

Toy car wheels

PRINTING IDEAS: YOUR TURN

Pour a little ink (or whatever you are using as ink) onto an old or disposable plate. Press your object into the ink and see what marks can be achieved by pressing that object to paper to create a print. There are endless possibilities for creating marks in this way. Glue your printing experiments to these pages.

Whether used on its own or in conjunction with hand drawing, printing with objects offers a creative, inventive, and beautiful way to make drawings. There is also something very pleasurable and rewarding about working in this way. It's likely many of us haven't created prints in this way since childhood. Take time now to enjoy the process of making prints—the joy of selecting our materials, the physicality of the liquid ink, and the pressure on paper before the exciting print is revealed.

TIPS

- ◆ Notice how the amount of ink you use alters the effect.

- ◆ Be sure to label each print with the object you used to make it so that you can easily replicate these marks in the future.

ADVENTURE

11

Hello Ink

Welcome to another messy adventure! Cover tables and wear old clothes or pick a sunny day to work outside. Again, I used India ink—this time diluted with water to create the work, but you could use strong black tea or coffee, watercolors, or diluted poster paint. So far we have used ink with a paintbrush and for printing objects, but in this chapter we are going to explore and exploit what ink can do on its own.

For inspiration, look up Jackson Pollock, who was famous for his violent, expressionist drip paintings. He would lay the canvas directly onto the floor and then paint in a highly physical manner, dripping, splashing, and pouring layers of paint from above. Ian Davenport is another exciting artist; he uses household gloss paint poured from syringes, allowing the paint to naturally flow down the surface in ordered stripes.

Ink offers a very exciting way to create spontaneous and unpredictable marks. It is a more physical approach than we have previously used, requiring more body movement to create a wide and diverse range of marks. This exercise promises a real sense of fun and play and a chance to return to a type of drawing that you may have left behind in childhood.

You will need some disposable cups (or, if you are using tea or coffee, mugs are fine), your paintbrush, a drinking straw, salt, plastic wrap, and a crayon or oil pastel.

TECHNIQUES

Pouring

Here I added a small amount of ink to a disposable cup, held the page vertically, and poured the ink across the page, allowing it to run down the page in stripes.

Flicking

To create these flick marks, load your brush with ink, hold it above the page, then flick your wrist to splat, drip, and spot the ink onto the paper.

Wet-on-Wet

If you paint the paper first using your paintbrush loaded with clean water, then drip ink on top, the mark will bleed and flow. This technique—essentially painting onto an already-wet page rather than onto dry paper—is called wet-on-wet.

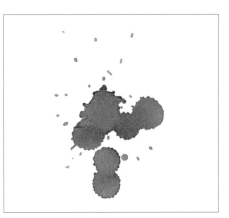

Drips

To create drips like these, load your brush with plenty of ink and then hold it vertically and very still above the page, waiting for the ink to fall off in a drip. This creates more predictable and circular marks than flicking the wrist.

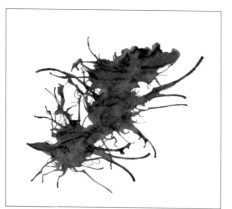

Straw Blow

Pour some ink onto the page and then hold a drinking straw above the ink and blow. This creates really beautiful organic lines, which remind me of tree branches.

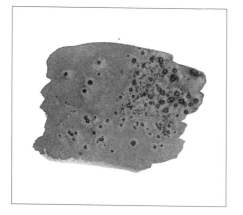

Salt

Sprinkle salt onto wet ink and allow to dry completely. The salt will absorb the ink, leaving a speckled effect.

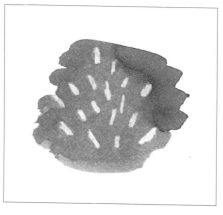

Wax Resist

Use a wax crayon, oil pastel, or candle to create marks and then paint over with the ink. The wax repels the water, allowing the marks to be seen clearly through the ink.

Plastic Wrap (cling film)

Apply plastic wrap to wet ink and allow to dry completely overnight. The folds and creases will be replicated in the ink, leaving a beautiful folded texture.

PRACTICE TECHNIQUES: YOUR TURN

On these pages, glue your experiments with the many possible textures and effects ink offers.

We are gradually building up your toolbox with potential techniques. As we proceed, begin to think about those you like most and how they might be used and combined.

TIPS

◆ Make sure that you clearly label how you managed to make these marks so that you can easily replicate them in the future.

ADVENTURE

12

Drawing as Space

Drawing as space?

Yes, here the drawing is composed of the areas of empty space created by piercing the paper with a needle. The front side of a paper piercing piece is supposed to be the back, or, the side where the pin emerged—the side with the more obvious holes. But it's interesting to try both, experiment, and use whichever side you prefer.

This is such a beautiful and subtle way to draw, and I frequently use this technique in conjunction with other methods. I really enjoy piercing words and sentences into my drawings; it adds texture and acts as a secret message contained within, often unnoticeable at first sight. I always make my piercings freehand instead of lightly sketching them in pencil first, as I feel that this provides a more organic, wobbly result. I guess that because I am so drawn to using dots to shade and texture my drawings, a pierced hole is bound to be something I'd enjoy!

You're going to need something to make your holes—a push pin, safety pin, or ideally some sewing needles—and it's nice to have a few of various thicknesses. It's best to use a thicker piece of paper or a thin cardstock for this exercise as thinner papers are more likely to tear. You also don't want to bore holes into your desk, so make sure that you have some corrugated cardboard, an old mouse pad, or a piece of foam core behind the paper when piercing a hole. Finally, you'll need your soft graphite pencil.

STARSCAPE

For this adventure you're going to re-create the night sky on the opposite page using pierced holes for stars. It's probably best to create this on a separate sheet of paper and then tape it onto this page (otherwise the next adventure will also be full of holes!).

First, use a dark graphite pencil to shade your page. Smoothly color in the background to make a dark sky and then you can try adding darker masses in some areas to suggest clouds. Decide if you'd like to pierce holes through the shaded or white side of the paper. Then take your needles and pierce through this dark night page to show the stars. You can add them randomly or in the shape of constellations.

Glue your own version of the night sky on the opposite page. Through the holes we will see this white page, which will depict the bright stars. Make more of these night sky pieces to tape up against windows, or use them to create lampshades, as paper piercing looks incredibly beautiful when light is allowed to stream through the holes.

TIPS

- ◆ Push straight down with your pin or needle rather than at an angle to make a neat, even hole.

- ◆ Compare the different holes made with a needle, push pin, or safety pin, then exploit these different effects in your drawing.

ADVENTURE

13

Drawing Blind

Blind-contour drawing means drawing an object or scene without looking at your paper. This is the perfect exercise to develop our observation skills, since we are forced to completely focus on our subject rather than fiddling with the drawing on the page. As our drawings improve, we need to get used to spending most of our time observing the object with only very quick glances at the paper from time to time.

For this exercise you are not allowed to look at the paper at all, which is actually harder than it sounds. If you're anything like me you'll be itching to have a look at your drawing, but it's important to RESIST that urge. The hardest part of this exercise is losing your way—once you take your pen off the page, it's very difficult to work out where in the drawing you are, so it's tempting to take a quick glance. But by creating a drawing without looking at the subject, you will start to "feel" the outlines of the object, training yourself to draw what you can actually see rather than what you think you should see.

I find that working in this way allows me to relax and enjoy the process of creation—I can't worry about how the drawing is looking, because I can't see it. This is another exercise I use when I need to warm up and loosen up. It's an invaluable way to begin sketching anything new, as it gives you space to properly observe and understand the subject. This adventure will produce drawings that in some areas may seem muddled and disoriented, but in many others will be beautifully observed, demonstrating the enormous value of keen perception.

BLIND CONTOUR

I have a small ceramic mug on my desk filled with five pens, a pencil, and a highlighter. I used a large, hardcover book to block my view of my drawing paper (so I couldn't see the paper and, therefore, couldn't cheat!) and then drew the pen mug. After the exercise, I was able to see many places on the page where I lost my bearings and I failed to join the handle to the mug. (Figure 1)

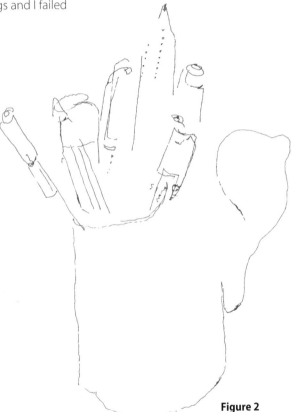

Figure 2

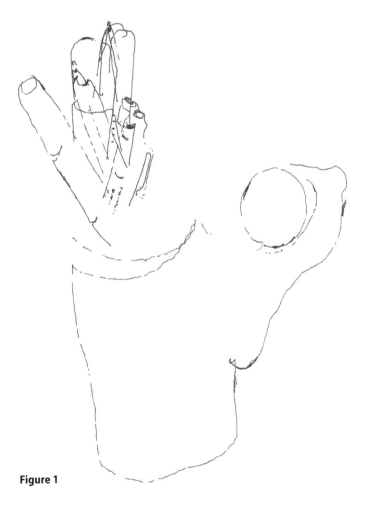

Figure 1

My second attempt at the same object is a little better as the pens are more spread out, but again the handle isn't attached to the mug. I'm not surprised that this one is better—after having looked so closely to draw it once, I was bound to have a better understanding of the subject this time. (Figure 2)

Your turn. Grab a mug filled with pens, or select any other object you like. Use a hardcover book to block your view of your drawing paper, then use your eyes to feel along the outlines of the objects and reflect them on the paper. Don't move anything and try this exercise again—is your second try better? What elements of these drawings please you? Which do you feel are really accurately observed?

As we move on, remember to spend most of your time looking at the object you are trying to draw instead of at your page. You only need to glance occasionally at your page to orient your lines. Remember that all the information you need to create your drawing will be found by looking at your object, so train your focus there.

Include your drawing here:

TIPS

- If you find that it's too disorienting to lift your pencil from the page, try using a continuous-line approach—draw the entire object without lifting your pencil from the page.

14

Drawn to Sound

In this exercise, you will be drawing under the influence of sound. By focusing on a wide range of different noises and responding on the page to what you are hearing, you can create a drawing that is defined by highly personal abstract marks.

I find that I have to be very careful about what music I listen to when I'm in the studio, as it really affects the quality of line and types of marks I create in my drawings. Drawings are a portrait of both the subject AND the person who is drawing. It is clear in the work if the person was feeling relaxed, rushed, or anxious, and music can provoke these and many other emotions. On the whole I tend to avoid music while I am working, as it just has too great an effect on my line. Instead I listen to talk radio, as I find I can zone out, focus, and maintain a constant approach to my

work. In this exercise, however, we will experiment with the effect that music can have on the types of marks we create. We might be able to discover new ways of drawing that can be added to our toolbox of techniques.

You will need your 2B pencil, and a WIDE selection of music. Don't worry if you don't own lots of different music; you can access diverse musical genres by either tuning in to different specialized radio stations or entering a variety of music genres into YouTube.

For this adventure we are focusing on creating lots of abstract marks by allowing the sounds to inspire the pressure of the pencil on the page, the speed at which we draw, and the shapes that we use.

SOUND AS ART

Here you can see my range of marks; I've also noted the sounds I was listening to when I created the marks. I found it helpful to close my eyes, adjust my pressure, and change my grip on the pencil to enable the widest range of marks.

Birdsong

Drilling

Traffic

Classical

Folk

Heavy metal

Jazz

Soul

Reggae

Gregorian chanting

PRACTICE: YOUR TURN

Now it's your turn! Fill this spread with marks, remembering to make note of what you were listening to when you created the drawing. Try this exercise more than once, listening to a very wide range of noises and forms of music each time, as this will provide the greatest contrasts in your drawings.

Have you made marks that seem alien to your hand? It's really exciting to be able to tap into an entirely new way of mark making, which may inspire you to use a wider range of marks as we go on.

Birdsong

Drilling

Traffic

Classical

Folk

TIPS

- I found it helpful to close my eyes. Then I was able to really focus on the music and make more spontaneous marks.
- Write down the sound heard next to each drawing for future reference.

Heavy metal

Jazz

Soul

Reggae

Gregorian chanting

ADVENTURE

15

Drawing Again and Again

Drawing something again and again provides an opportunity to really explore and understand the item you are drawing. It enables us to become less precious about the quality of each individual drawing, as we know we have many more to complete. As we repeatedly draw the object, our familiarity and confidence with the subject will grow. In time and with practice, our drawings improve.

Many artists will create drawings from the same view, model, or still life over and over again, allowing a chance to experiment and improve. For example Monet often created his paintings in series, repeating the same subject again and again, inspired by the changing conditions of light, weather, and season.

He created more than thirty paintings of Rouen Cathedral, and I highly recommend you look them up to see the many different approaches this master painter took in this exercise.

For this adventure, I will give you prompts to suggest possible ways to approach each drawing. If the subject matter I suggest (for this exercise it is a peacock feather) or the prompts don't appeal to you, then please find an object and approach that is inspiring. I want each adventure you undertake in this book to bring out your best work. To this end, it's important to love what you draw—especially if you are being asked to draw it over and over again!

TECHNIQUE SAMPLER

Here I have tackled a peacock feather, allowing myself to explore a different approach each time.

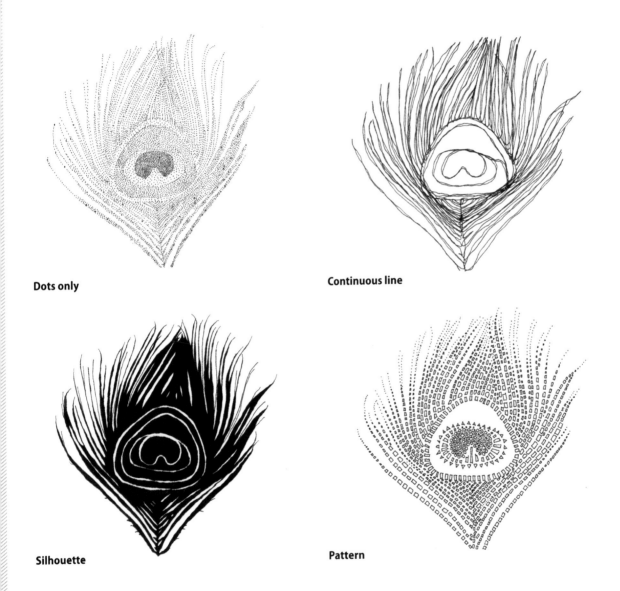

Dots only

Continuous line

Silhouette

Pattern

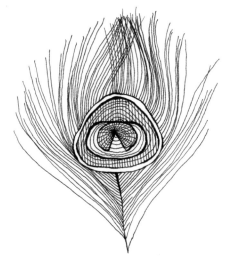

Cross-hatching

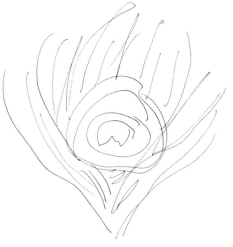

10-second sketch

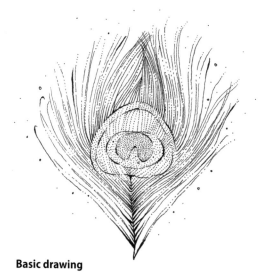

Basic drawing

Blind-contour drawing

CHOOSE A SUBJECT

Now it's your turn! If a peacock feather doesn't appeal, then try one of the following ideas. You'll need to draw this item many, many times, so find an object that really interests you!

- Leaf
- Headphones
- Pinecone
- Stapler
- Seashell
- Shoe
- Keys
- Hairbrush
- Fork

- Camera
- Favorite ornament
- Scissors
- Bottle of perfume or aftershave
- Piece of fruit: orange, apple, banana, grapes, etc.
- Child's toy
- Flower
- Decorative jug or vase

TECHNIQUES

Here are a few hints for different approaches to try as you draw your subject. Feel free to invent many more of your own!

- Dots only
- Colored-in shape
- Continuous line
- Patterns

- Cross-hatching
- 10-second sketch
- Blind-contour drawing

PRACTICE:

Draw your chosen subject again and again on this page using lots of different techniques.

By now you are very familiar with your subject. Take a moment to look at the drawings you just created. Can you see an improvement in your work as you gain more confidence and experience? Now is a good time to review the work you have created and see how far you have come. Make a list of the approaches, marks, shapes, and lines that you are using consistently in your drawings. These repeating elements reveal the emergence of your own personal artistic style. The more you practice and continue with drawing, the more your style will develop and become apparent.

16

Drawn to Mono Printing

Mono printing is a unique type of printmaking that produces beautiful, painterly drawn lines. Unlike many other forms of printmaking that allow the production of multiple copies, mono prints are created only once. Although you can create similar prints, no two will be exactly alike.

I would suggest you look up the mono prints of Tracey Emin, which frequently combine areas of text with figurative drawing. The scratchy lines give the prints a sense of desperate speed and intimacy, and, due to her dyslexia, there are often misspellings and letters appearing back to front. Consider how different these images would look if they were pencil drawings rather than mono prints. How might you respond to them differently, and what does the process of printing add to the work? There is certainly a romantic quality to mono prints and an intimate sense of the artist's hand, both in the lines created and in the spontaneous textures in the beautiful mottled marks made by the hand or arm pressing against the page.

To complete this adventure you will need an oil pastel, a ballpoint pen, and some printer paper. Mono printing is usually done with printing ink, a sticky, thick ink that produces wonderful results. Printing ink, though, is rather expensive and VERY messy, so for now we're going to use an oil pastel (a wax crayon won't work for this). If you enjoy this method of working, I encourage you to buy printing ink and create mono prints in the traditional way. I, however, still prefer the ease and convenience of the oil pastel!

TECHNIQUE

First, scribble oil pastel all over a sheet of printer paper. You do not need to completely cover the sheet with color, but you'll need to get a good layer of pigment down before you print, as wherever there is not oil pastel, no drawn line will show.

Now lay a sheet of paper over the oil pastel, and, using a ballpoint pen with medium to heavy pressure, create a drawing. Mine was inspired by a tulip. Remember that because this is a mirror image, you will need to draw numbers or text backwards to make sure they face the correct way in your print.

Once your drawing is complete, peel the paper away from the oil pastel surface. You will see that you have created a beautiful mirror image of your drawing in oil pastel. You can also create textural soft shadows and marks in your print by pressing your fingers or the side or flat of your hand against the paper before peeling it away from the pastel surface.

Now it's your turn to create your own mono print of something that inspires you. Attach your favorite print to this page.

ADVENTURE

17

Drawing as Stitch

I love to use stitch in my drawings. My stitched work is rather wobbly, irregular, and obviously done by hand, but it creates an intimate texture, introduces craft, and contrasts nicely with the drawn lines on the page. A quick Google image search of stitched drawings will reveal a wide range of deeply inspiring and creative approaches to drawing with stitch. Take a look at the work of Peter Crawley, who creates intricate architectural drawings by piercing watercolor paper with a pin and then using a needle and cotton thread to join the holes. The patience and speed taken is recorded in these wonderful pieces, and their neat, technical rendering becomes truly astonishing once you look closer and realize that each line is stitched. For this adventure you can either create a completely stitched drawing, or embellish an existing (or brand new) drawing with stitches.

Try completing this exercise WITHOUT lightly drawing your proposed stitch design in pencil first, as it will be hard to erase without damaging the holes. Instead be brave and plunge in freehand. Creating a path for stitching by piercing all the holes first does slow down the process, but once the holes are added, the simple task of joining the dots becomes a relaxing and meditative one. Enjoy this slower pace and take time for contemplation.

STITCHES

Let's begin by exploring the types of stitch we might want to use in our drawing.
Thread your needle then try the following basic stitches.

Running Stitch

1. Use a needle to push holes into the paper to create a design.

2. From the back of your paper, push your threaded needle up through the first hole and down through the second hole.

3. From the back of your page, push your threaded needle up through the third hole and down through the fourth hole.

4. Repeat the process, stitching up from the back of the page and down through the next hole, linking all the holes you have made with stitches.

5. Once you've completed the stitching, pull the thread to the back of your page and tie a knot to prevent your stitches from unraveling.

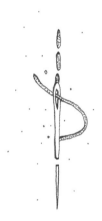

Back Stitch

1. Use a needle to punch holes in your paper, creating a design.

2. Use running stitch to connect the first two holes.

3. From the back of the page, push the needle up to the next hole.

4. Thread the needle back through the end of the first running stitch hole to create a continuous line.

5. Continue stitching up from the back and through the last stitch, working your way down the row of holes.

6. Once you've finished stitching, pull the thread to the back of your page and tie a knot to prevent your stitches from unraveling.

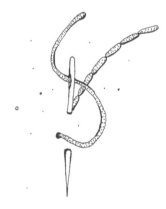

TIPS

- If you have a thicker piece of paper or thin piece of cardstock, use that for this exercise rather than the thin printer paper we have been using.
- You MUST create the holes in the paper first, and then use the threaded needle to join the dots. The paper is not as flexible as fabric, so if you try to create the hole and sew through it at the same time, it is likely to tear.
- Place a sheet of foam core or corrugated cardboard under your page to protect your table or surface from pin holes.

Cross Stitch

1. Use a needle to pierce four holes per cross stitch. Imagine a square and pierce a hole through each of the four corners.

2. Thread your needle and come up from the back of the page through the hole in the bottom left corner of the first cross-stitch square.

3. Stitch on the diagonal and bring the thread down through the top right hole.

4. Come up through the bottom right hole and again stitch diagonally across the square, then down through the top left hole to make a cross.

5. Once you've finished stitching, pull the thread to the back of your page and tie a knot.

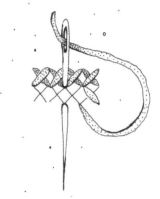

French Knots

1. Use a needle to pierce a hole in your paper.

2. From the back of the page, pull the threaded needle through the hole.

3. Wrap the thread around the needle twice, keeping thread near the point.

4. Push the wrapped needle through the hole, leaving a knot on the surface of the paper.

5. Once you've finished stitching, pull the thread to the back of your page and tie a knot.

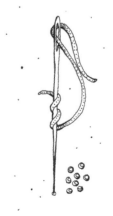

MY PIECE

Here's a drawing created for an exhibition in Japan embellished with running and cross stitch to draw a circle and write the phrase "I love you." I used a needle to create all the holes in the paper before stitching them together.

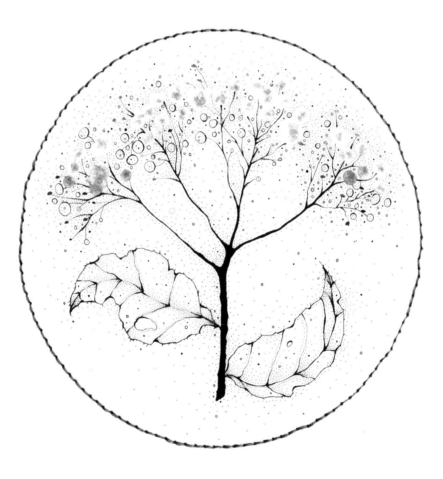

l love you.

YOUR PIECE

Use this page to glue your own stitched drawing, perhaps a quote or song lyrics that inspire you. You can either combine the stitches with hand drawing as I did or just use stitch.

TIPS

- Don't make your holes too close together, as they are more likely to tear.
- Use the needle with which you plan to sew to make your holes to ensure that the holes are the right size.
- To make a neat hole, push the needle straight down rather than at an angle.

Drawing from Your Imagination

In this chapter we'll begin to explore imaginative drawing. The previous exercises have focused on drawing from life and learning many different drawing skills and techniques. With this new grounding in drawing skill, we can now seek to draw from our imaginations.

This project is inspired by a window installation I created for the Le Bon Marché department store in Paris. Each of the windows had life-size plastic animals on plinths, and I illustrated surreal, wacky legs for each animal. I really enjoyed dreaming up bizarre and humorous juxtapositions between the plastic animals and their funny legs. It was so much fun that I wanted to share it here as an exercise so you can play too! All you'll need for this chapter is your graphite pencil and a big sense of fun!

Here is a photograph of one of the windows from the installation in Paris. It's a deer with the extended legs of an elephant.
Photograph by Emma Brown

MINE

Here are three identical ducks with very surreal "legs"
inspired by a ballerina, a flamingo, and an octopus.

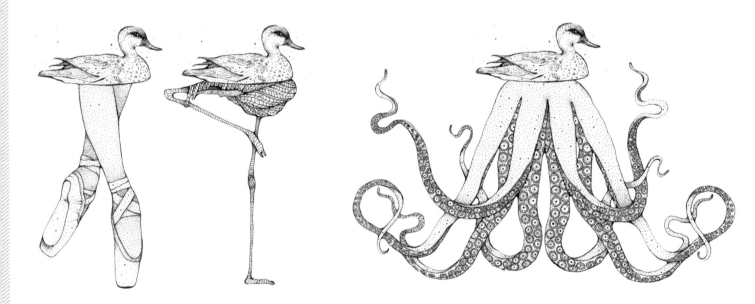

YOURS

Okay, your turn! What legs will you give these ducks?
How about pencils, baguettes, yarn, bananas, or a unicycle?
Let your mind wander and play with the possibilities.

TIPS

◆ If you prefer, feel free to use printing, frottage, or collage instead of hand drawing, or use a combination of techniques.

◆ Don't be afraid to use reference imagery to help you to draw. Remembering how things look is not the point of this exercise—instead use your imagination to come up with clever ideas for the legs.

ADVENTURE

19

Drawn to Growth

In this chapter we're going to work with an existing picture. Found imagery offers a great pathway to learning about composition, or how things are arranged in a picture. It's also lovely to begin a drawing with the sense that part of it has already been done for you. The found picture offers a clear subject matter, which serves as a springboard for our imaginations to expand upon, allowing us to shape the world created in the image into one that encompasses our own ideas and interests.

Spend time looking for an image that you really love. Ideally you're after something that will spark further ideas to extend the image into a far larger work of art. Here are a few ideas for places to search.

- newspaper or magazine
- old drawing (by you or another artist)
- scanned image from a book
- postcard or greeting card
- leaflet or catalog

MINE

I used a postcard featuring an old drawing I'd made of a cherry tree. I spent time deciding where to paste it and then extended the drawing to include more of the tree and a boy reaching up to pick a cherry. Other ideas I had were to extend the original drawing by adding a bird's nest full of hungry chicks, or to depict the cherry branch in a vase on a table with a big bowl of cherries and ingredients ready to bake a pie.

YOURS

Once you've selected your found image, study the scene and brainstorm a context beyond the edges of your picture. What is happening outside of the frame? What is going on in the image? What do you think happened before or after the picture was taken? What does this picture remind you of? Think carefully about where on the page you want to stick your found image, then sketch out an extension of your image.

Don't worry too much about the final drawing; this exercise focuses on the pleasure of using your imagination to create your own world. Revisit this exercise later, using the same or different imagery to measure how far you have come.

TIPS

Feel free to draw on any of the skills we've covered so far. Think about the following:

- ◆ Pressure, speed, and pencil grip

- ◆ Incorporating more found imagery as collage to extend the original work

- ◆ Creating some individual prints and frottage

20

Print Masterclass

This adventure is a chance to revisit many of our different printing skills and combine them in a finished collage. We'll be looking again at mono print, frottage, drawing with scissors, and object printing.

Use my collage as a springboard for your own ideas. Choose a subject that inspires you and use any combination of techniques we've explored so far to create your own work. Flip through previous chapters to remind yourself of favorite techniques and approaches to use again here. As always, try not to be too concerned with the finished piece, but focus on the process of creation and enjoy the physicality of this mixed media approach.

PRINT COLLAGE: LONDON EYE

For my collage I chose to depict a view of the River Thames in London featuring the London Eye. On the opposite page are some of the individual pieces I created with details of how I made them.

Birds and Sky

For the sky I watered down ink and splashed it onto the page. I then dabbed a kitchen towel into some areas to make them lighter and suggest clouds. I created the birds by folding a small piece of card into a V shape and using it to print the birds into the sky, adding a little hand-drawn detail.

River Thames

For the river I watered down ink and splashed it onto the page. Once dry I used scrunched kitchen towels to print dark areas in the foreground. I then cut out a strip of this dark area and glued it onto the lower half of the page.

Buildings

The buildings behind the London Eye Ferris wheel were created as mono prints. I cut out pieces of paper in the shape of the buildings and colored oil pastel on the back of these pieces. I then placed these shapes on the final artwork page (oil pastel side down) and used a ballpoint pen to create the mono print drawing of the buildings and windows.

London Eye

I created the London Eye by printing the rim of a disposable cup. For the spokes, I inked the edge of a piece of cardstock and used it to print the series of lines. I added the circular pods around the wheel using a cotton swab, and once it was dry, added some extra details with a fine line pen.

Trees and Platform

The trees on the far left are collaged on from sheets of frottage, and the dotty platform is printed using bubble wrap with hand-drawn embellishments. Once I'd collaged this piece in place, I had to reprint the areas of the wheel that I'd covered.

Buildings

I cut these buildings from sheets of direct prints (the central building was a portion of a large leaf print) and frottage (I created rubbings from tarmac).

YOUR COLLAGE

Use the following page to create your own collaged image. Choose a subject that excites you and try to use as many of the different printing and collage techniques as you can. For this adventure, you'll need the following supplies.

- Stack of printer paper
- India ink (or a substitute such as strong cold coffee, watercolor, or poster paint)
- Oil pastel(s)
- Wax crayon(s)
- Scissors (large and small)
- White PVA (Elmer's, school, or similar glue)
- Collage papers (tickets, receipts, postcards, etc.)
- Suitable objects for printing or frottage (determined by your subject)

TIPS

- Once you have an image in mind for your collage, decide which technique you will use to create each element of the image.
- Place all of your carefully cut out elements to one side in a separate bowl or cup to prevent them from getting lost in your pile of clippings.
- Once you've made all of your elements, cut them out and spend time arranging and rearranging them on the page before committing to glue.
- Feel free to add hand-drawn elements at the end if you like.

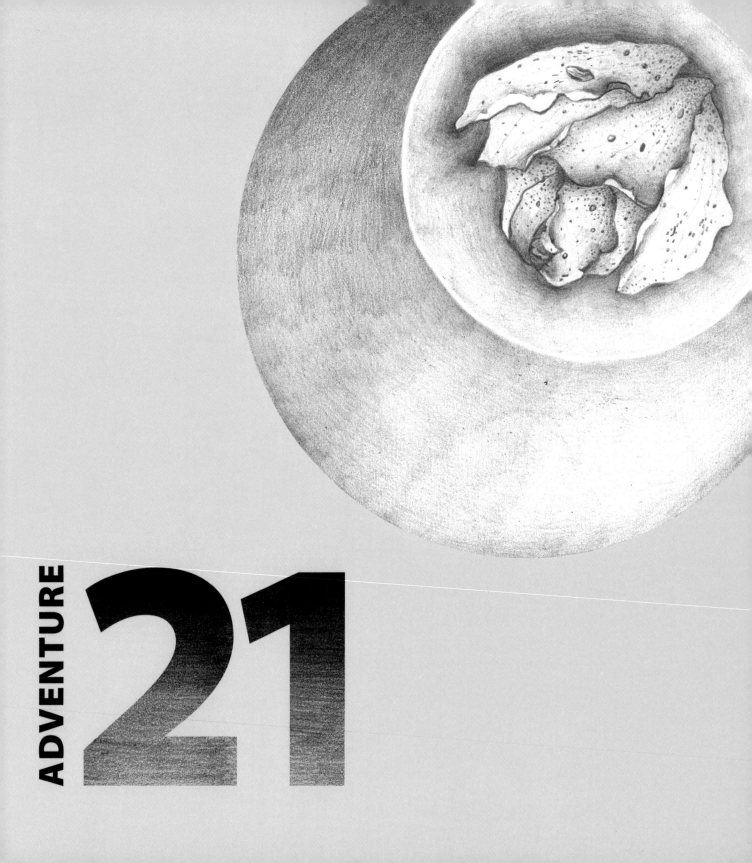

ADVENTURE

21

Drawing Masterclass

This chapter offers another chance to combine some of the many techniques we've explored together throughout the book, this time with a focus on the more traditional forms of drawing. We're going right back to the earliest adventures to revisit manipulating our pencil, paying special attention to the following:

- Pressure
- Line
- Shade
- Eraser drawing
- Pattern
- Paper piercing

I am always inspired by the natural world. My subject for this project is a rose, but again, I encourage you to find a subject that excites you. Because I always work in pen, I enjoyed this opportunity to play with the wide variety of effects that can be created using a simple 2B pencil. We are going right back to basics, so all that is really needed is your 2B pencil and eraser, but feel free to add other techniques if you wish, such as paper piercing, stitch, or collage.

MY ROSE

This is my final drawing of a rose, inspired by a painting I created in Paris.

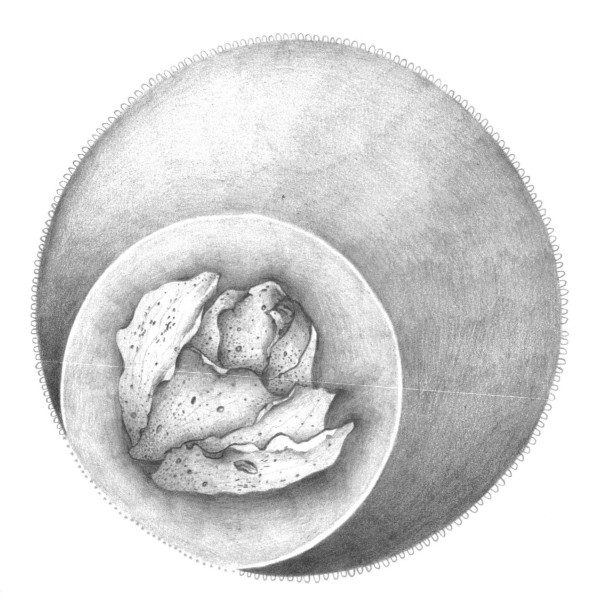

Dot Shading

I added lots of dots for shading and interest, taking time to color some carefully while applying other single dots more randomly with slight pressure.

Pressure and Line

I darkened areas of the line by applying more pressure and creating a thicker line. I think this variable line adds more interest to the drawing.

Eraser Drawing

I used the eraser with my pencil to push and pull areas of tone, adding darkness with the pencil and light with the eraser to get the effect I was looking for.

Shading

I used some dot shading on the flower, but much of the shading in this piece was created by adding smooth, graduated tones of gray.

Pattern

I created a scalloped pattern of semicircular shapes around the main circle.

Paper Piercing

I used a needle to add a section of paper piercing for texture and pattern.

YOURS

Time now for your final drawing in the book. Find a subject that excites you and then create a drawing directly into the pages here combining any of the following techniques:

- Pressure
- Line
- Shade
- Eraser drawing
- Pattern
- Paper piercing

TIPS

- Take time to revisit earlier chapters of the book to brush up on the techniques.
- Feel free to collage over areas and use additional skills we have explored instead of the ones I have suggested here.
- Consider adding texture with areas of stitch.
- I'm left-handed so I place a clean sheet of printer paper over the drawing on which to rest my hand so I don't smudge the work.
- Remember to spray the finished drawing with hairspray to prevent smudging.

ADVENTURE

22

Continuing Your Adventure

We have now reached the end of our adventure together, and it's time to fly ahead with drawing independently. This adventure will encourage you to look back at how far you have come, and it's full of tips to create the time and inspiration to continue your adventure.

With this book, my goal was to explore drawing in its broadest sense, using stitch, scissors, printing, inks, frottage, and collage. I wanted to expose you to as many different drawing methods as possible, to help you find your own way into (or back into) the joy of creating drawings.

The wonderful thing about drawing is how each person's approach and end result will always be different. Each one of these completed books will look completely different; yours is unique and celebrates your own approach and style. A drawing not only captures the view, model, or still life, but also an impression of the person who created it—you! Feel proud of how far you have come and confident that as you practice more and more your drawings will continue to improve.

YOUR PERSONAL STYLE

This book should now be full of you—your hand, your breath, your energy. Each person completing these adventures will have done so uniquely. Some drawings may be similar, but no two will be alike, and this is what I hope to leave with you: the joy of creating your own unique mark upon a page and the physical pleasure and mental space that comes with drawing. We all aspire to be able to draw something accurately, and developing this skill will come as you spend more time really looking, observing, and practicing. Eventually your hand-eye coordination will evolve and your hand will accurately capture what your eye sees. But I don't believe that we will get to this point unless we enjoy drawing. If drawing becomes a miserable, formal battle, we will quickly give up. So I truly hope that in the course of completing these adventures, you have found and enjoyed a range of approaches and techniques that you will add to your drawing toolbox and carry along as you continue on your journey.

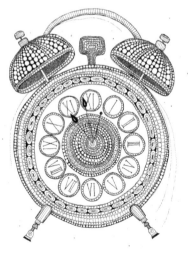

MAKE TIME TO DRAW

I hope that you will make the time to keep up with your drawing, time for you to be creative and inspired. As with any other skill, with practice your drawing will steadily and surely improve.

Finding the time to draw can be the hardest thing. If the washing needs doing, food needs cooking, and work seems to be occupying your every thought and minute, it can be very difficult to prioritize time for yourself. The best thing to do is to find ten minutes each day, because if you wait to find a spare hour, half day, or full day for drawing then it is unlikely to become a regular habit. It is only by drawing regularly that you will improve, and the quantity and consistency of drawing often will stop you from becoming too precious about individual drawings. Look for these sneaky ten minutes of drawing time in the following places:

- Instead of or in front of the television
- During lunch break
- On commute
- On the telephone

Failing that, you could set your alarm ten minutes earlier each morning and complete your drawing first thing! I would recommend you buy a small sketchbook (one that fits in your bag). If it's always with you, then you're able to grab the opportunity to draw whenever you can.

FINDING INSPIRATION

There will be other days when you've managed to find the time to draw, but you sit with your pencil and paper and no ideas come. On those terrible "I don't know what to draw" days, use one of the following ideas as a springboard:

- The clouds
- The view from your window
- Your hand or foot
- Something beginning with the letter D
- A birthday card
- Your favorite cookie
- Your pet, child, relative
- Your dream vacation home
- A winter scarf or summer hat

The point is, it doesn't really matter what you draw, as long as you draw!

Thank you for taking the time to read and complete these adventures with me. Drawing has the capacity to change, enrich, and document your experience of living in the world. I hope it will become a valuable and pleasurable part of your life.

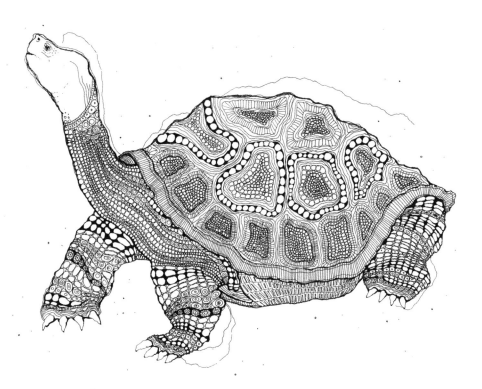

For Steve on our 16th year together. I love you very much.

Acknowledgments

I would like to thank the team at Quarry: Mary Ann Hall, Heather Godin, Kari Cornell, Renae Haines, and many more behind the scenes who have helped to make this book a reality. Jane O'Sullivan, for her friendship and being the best sounding board for my ideas for this book. And my wonderful family of Lemons, Hamblins, and Overtons: a huge thanks for their love and tireless support, Mum and Dad (Bert and Ernie), sisters Allie, Katy, and Al, brother Jim, and nieces Lily and Isabelle.

About the Author

Kerry Lemon is an artist working internationally for a wide range of editorial, publishing, and advertising projects. Her drawings are commissioned by clients such as the *Los Angeles Times*, Sony Japan, *Elle* Spain, Fortnum & Mason, Harrods, *Elle Decoration,* and *Harper's Bazaar.*

She is best known for her large scale retail and commercial installations collaborating with brands such as Liberty London, Harvey Nichols, Swarovski, Galerie Doux Dimanche in Tokyo, and Le Bon Marché in Paris.

Kerry lives with her partner Steve and their two naughty cats in a quiet village just outside London.

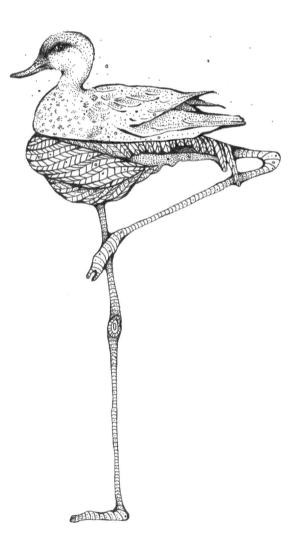